Do Judge A Book By Its Cover

All Rights Reserved © Emilie Malmros
Publisher E&M Publishing 2013
Photographs & Design Emilie Malmros

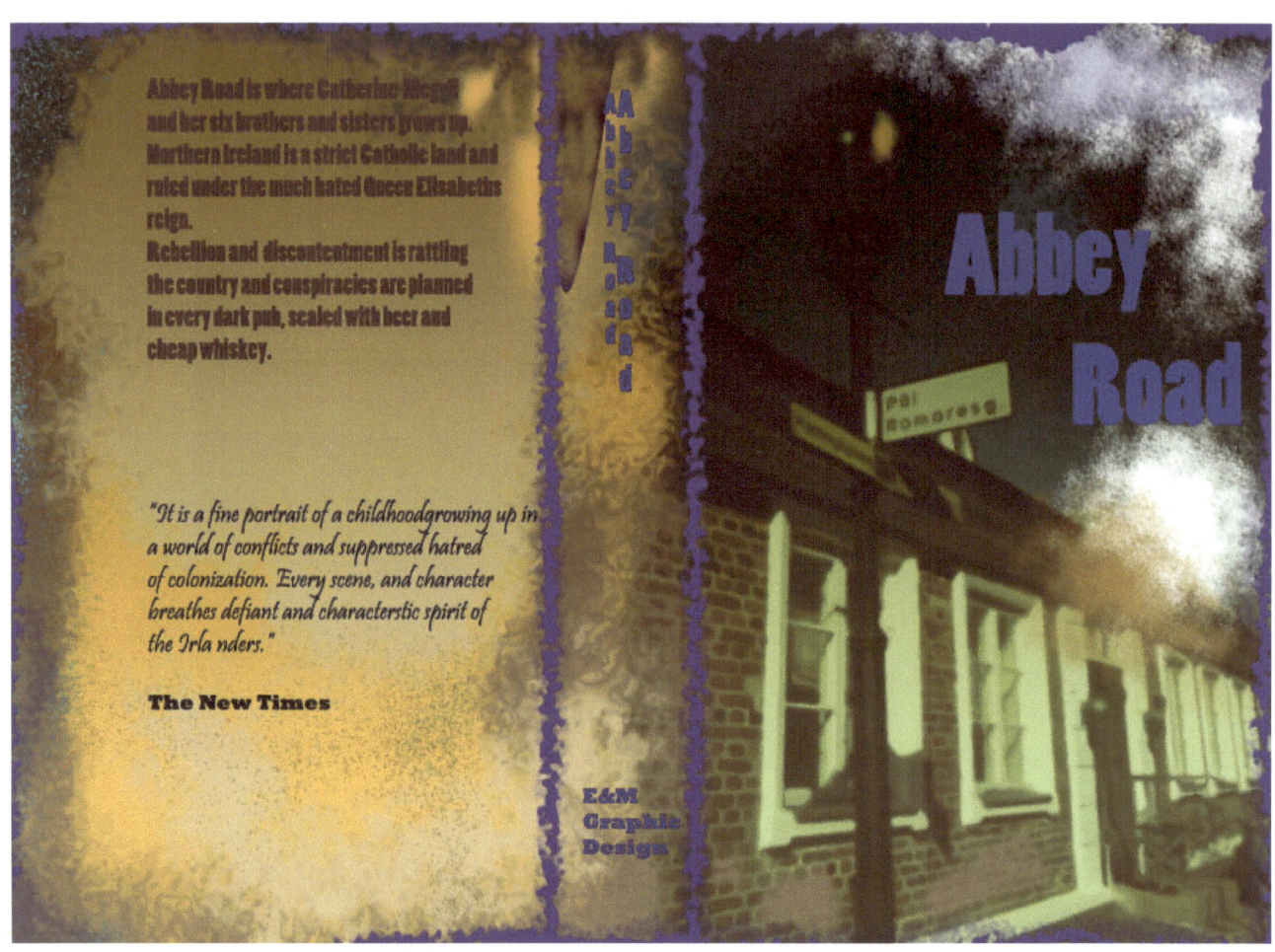

Abbey Road is where Catherine McGill and her six brothers and sisters grows up. Northern Ireland is a strict Catholic land and ruled under the much hated Queen Elisabeths reign.
Rebellion and discontentment is rattling the country and conspiracies are planned in every dark pub, sealed with beer and cheap whiskey.

"It is a fine portrait of a childhood growing up in a world of conflicts and suppressed hatred of colonization. Every scene, and character breathes defiant and characterstic spirit of the Irlanders."

The New Times

E&M Graphic Design

Abbey Road

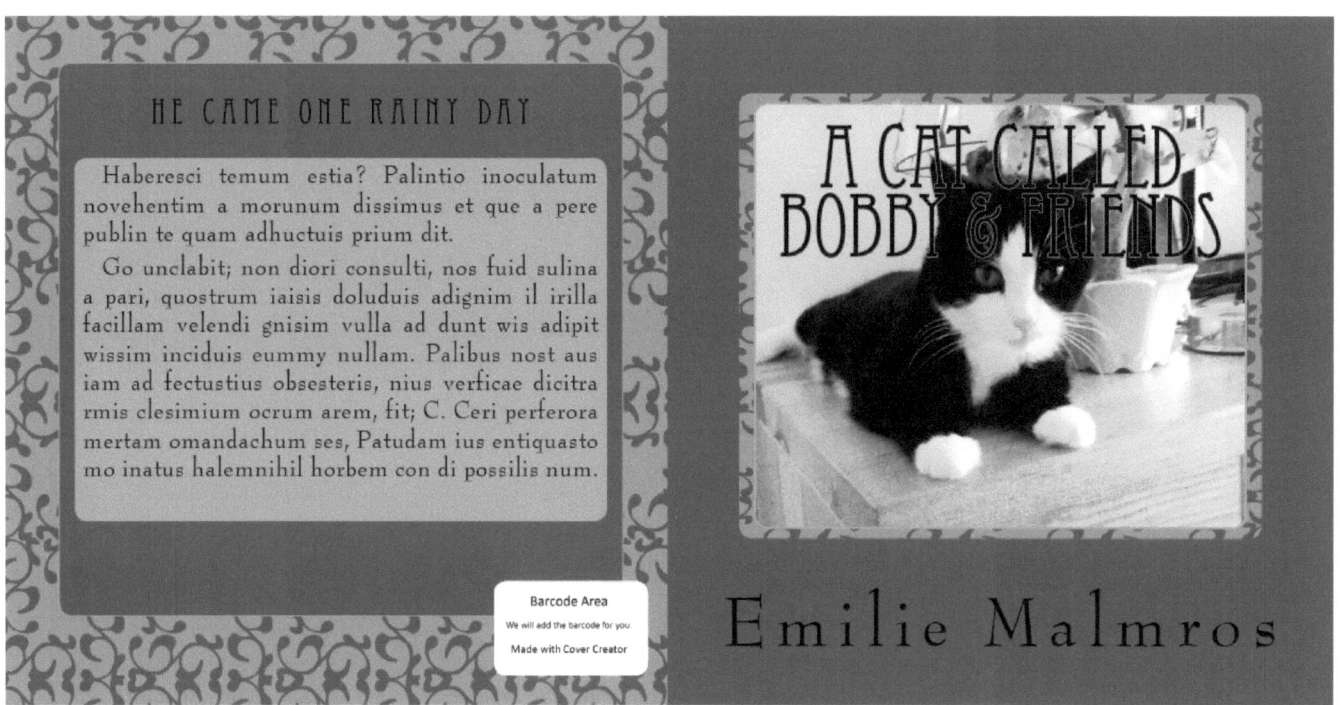

A CAT CALLED BOBBY & FRIENDS

DEAD GONE

Who is lying dead on the table at the Philaelphia coroner mortuary?...
They call her Jane Doe.
Will her identity be revealed?
And why she is there..

Or is she just Dead Gone.....

"Hard to put this book down, horrific exploration of all the worlds "Jane Does" in this world, people who go missing and no one misses them, no one looks for them.
They deserved moore..."

The New Times

E&M Design

DEAD

GONE

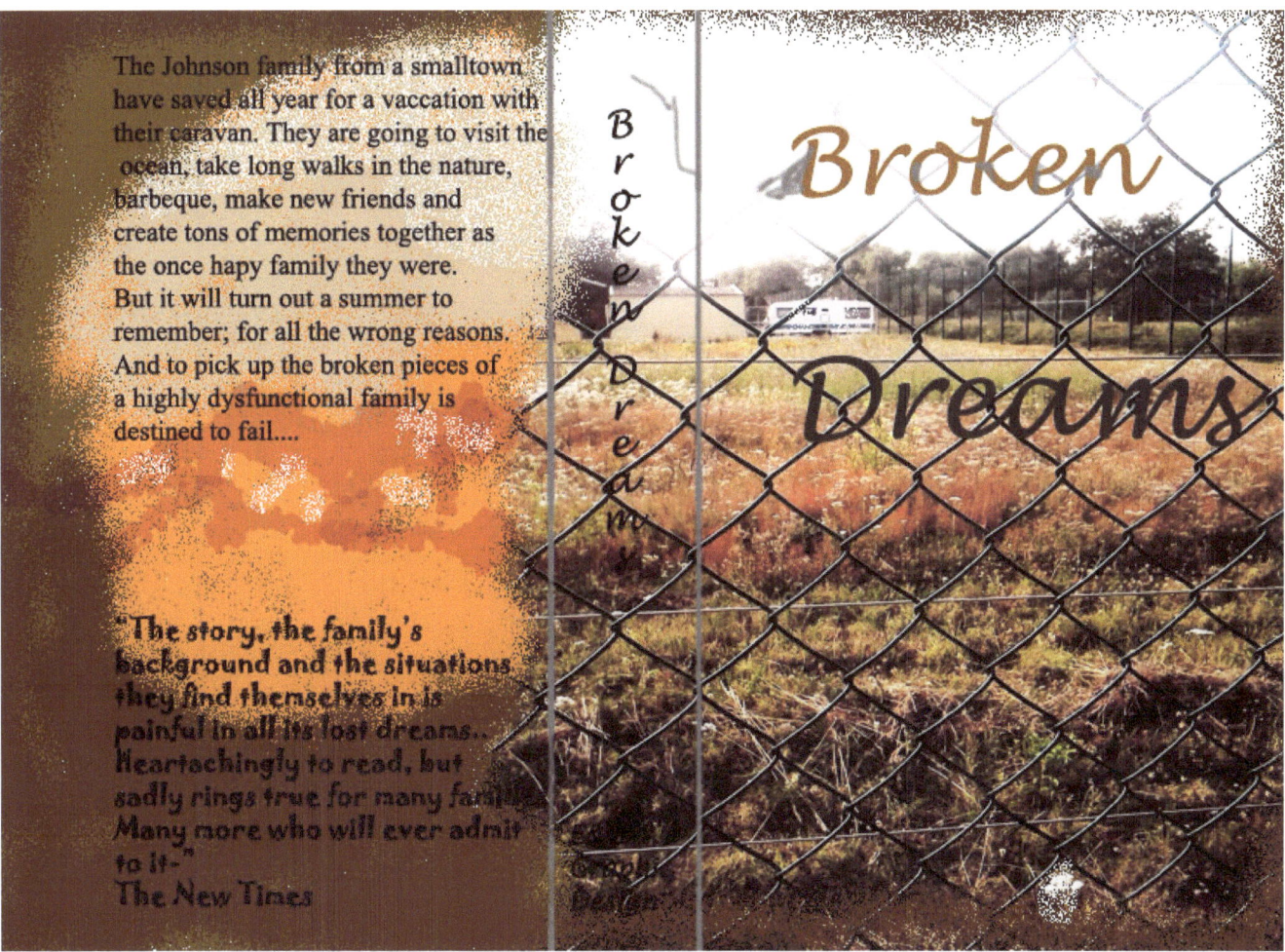

BROKEN DREAMS

The Johnson family from a smalltown have saved all year for a vaccation with their caravan. They are going to visit the ocean, take long walks in the nature, barbeque, make new friends and create tons of memories together as the once hapy family they were. But it will turn out a summer to remember; for all the wrong reasons. And to pick up the broken pieces of a highly dysfunctional family is destined to fail....

"The story, the family's background and the situations they find themselves in is painful in all its lost dreams.. Heartachingly to read, but sadly rings true for many families. Many more who will ever admit to it-"
The New Times

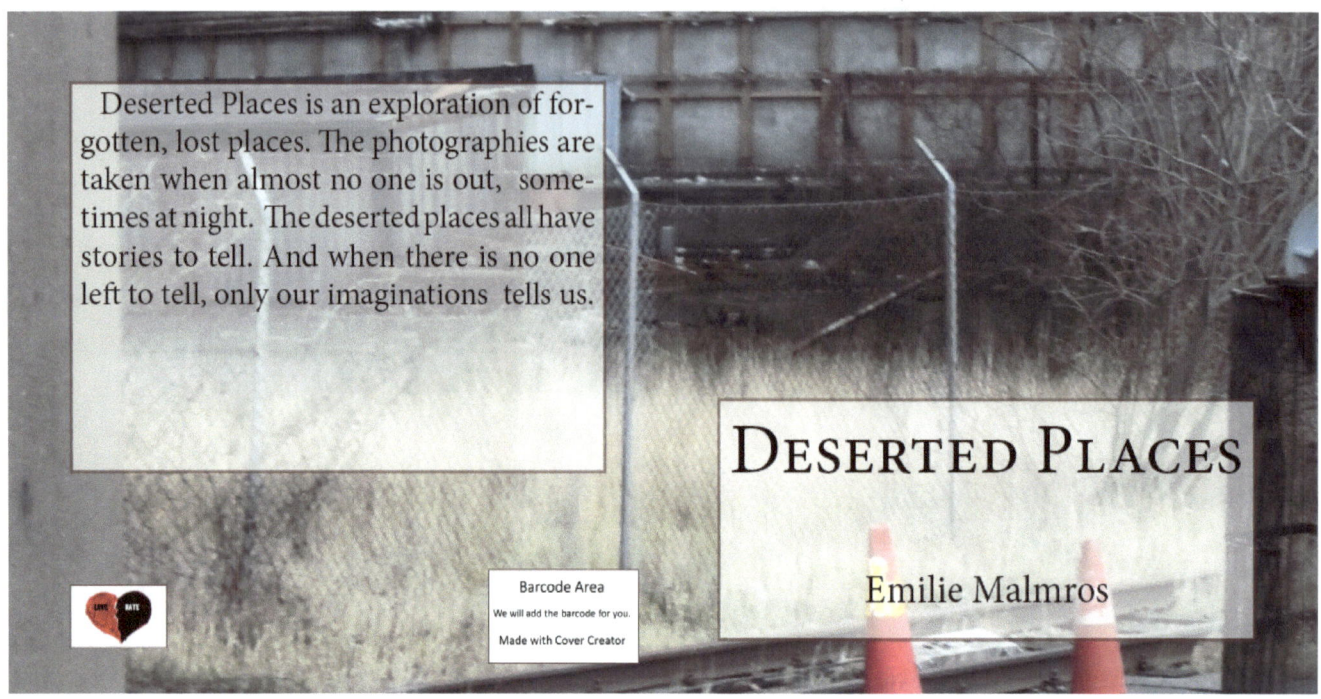

DESERTED PLACES

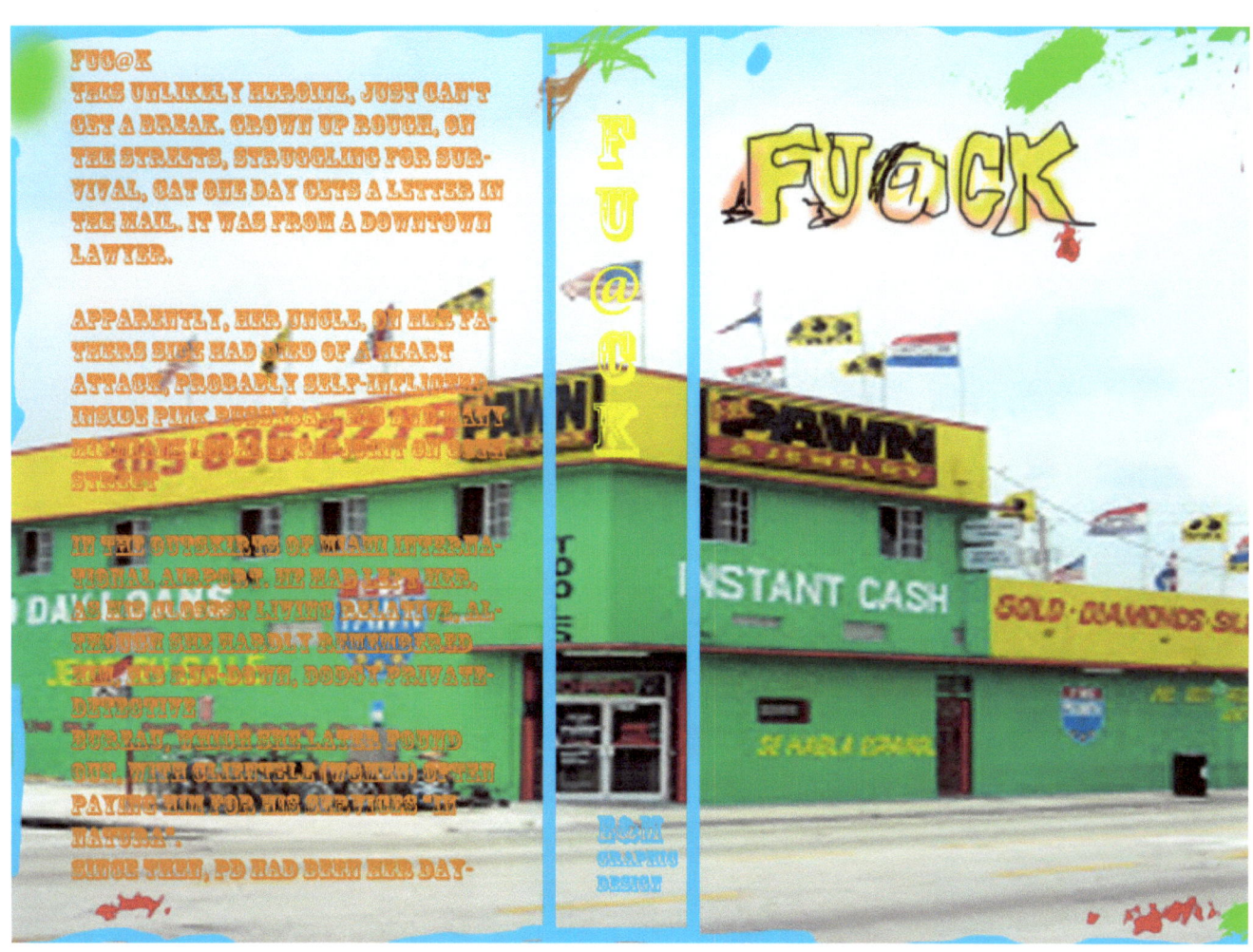

FU@CK

GIRL

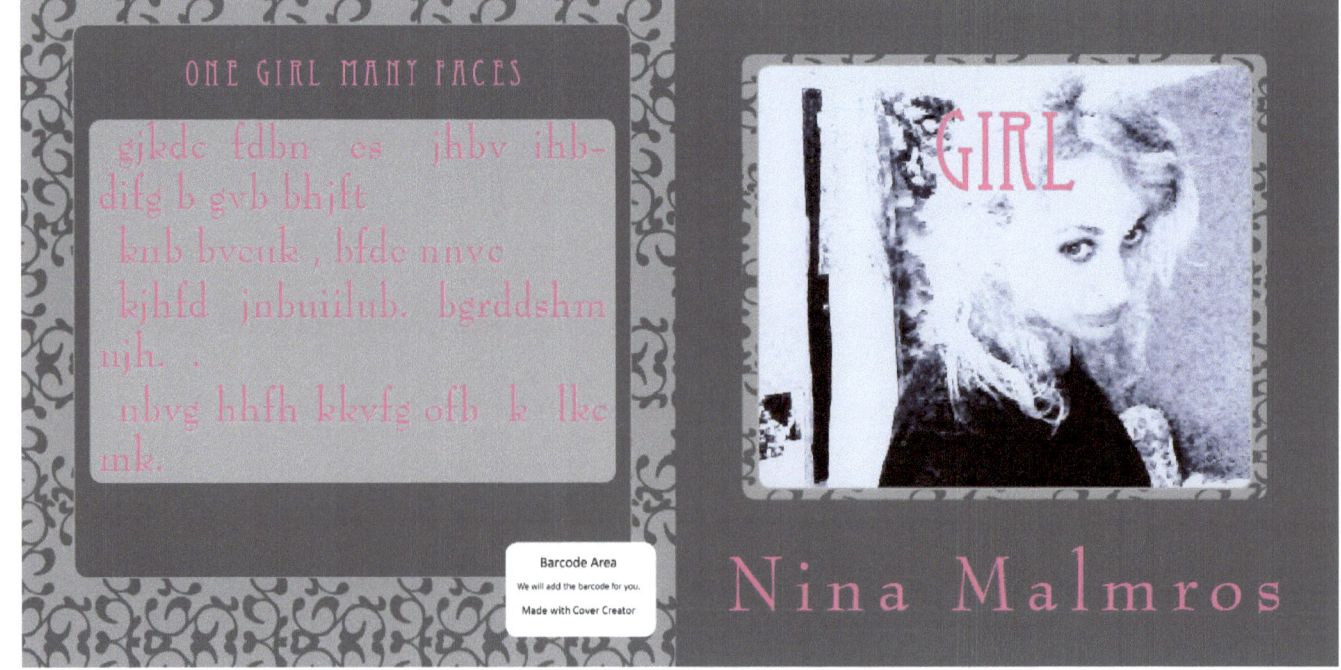

ONE GIRL MANY FACES

gjkdc fdbn es jhbv ihb-
difg b gvb bhjft
knb bvcuk , bfdc nnvc
kjhfd jnbuiilub. bgrddshm
njh. .
nbvg hhfh kkvfg ofb k lkc
mk.

Nina Malmros

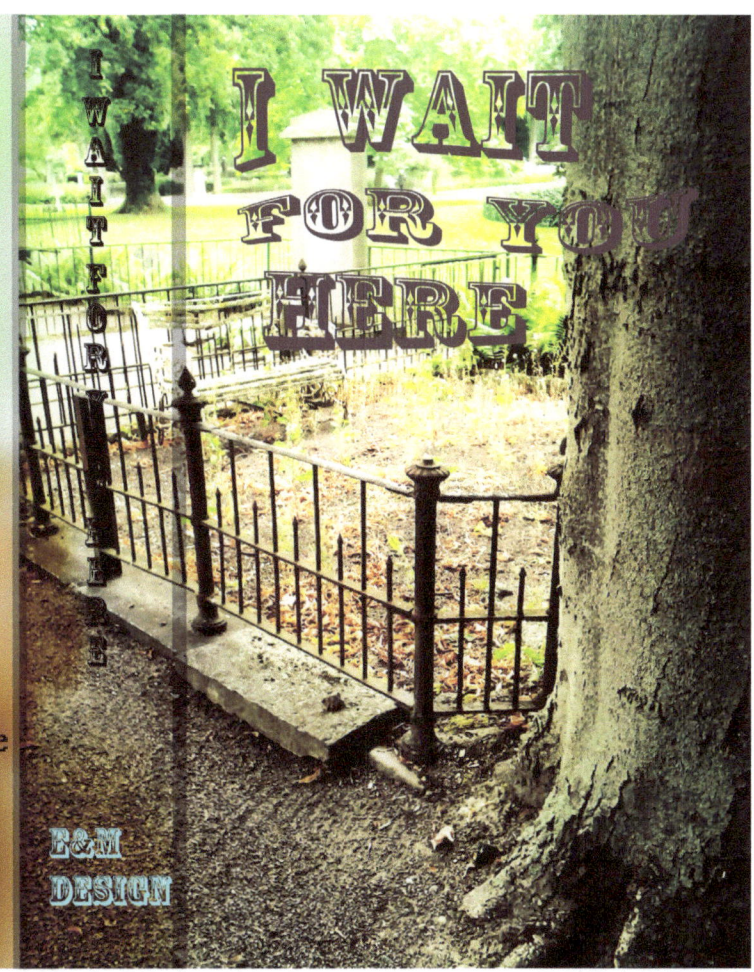

THE NEWLY WIDOWED MRS RANDALL, IS TRYING COME TO TERMS WITH THE LOSS OF HER YOUNG HUSBANDS SUDDEN DEATH AS A RAF PILOT IN THE SECOND WORLD WAR. HER LONELINESS AND DESPAIR IS SHARED WITH MANY OTHERS WHO LOST A LOVED ONE TO THE BITTER WAR.

"I wait for you here", gives a deeper understanding of the sufferings and
losses the civilians paid during the world war II."

The New Times

I WAIT FOR YOU HERE

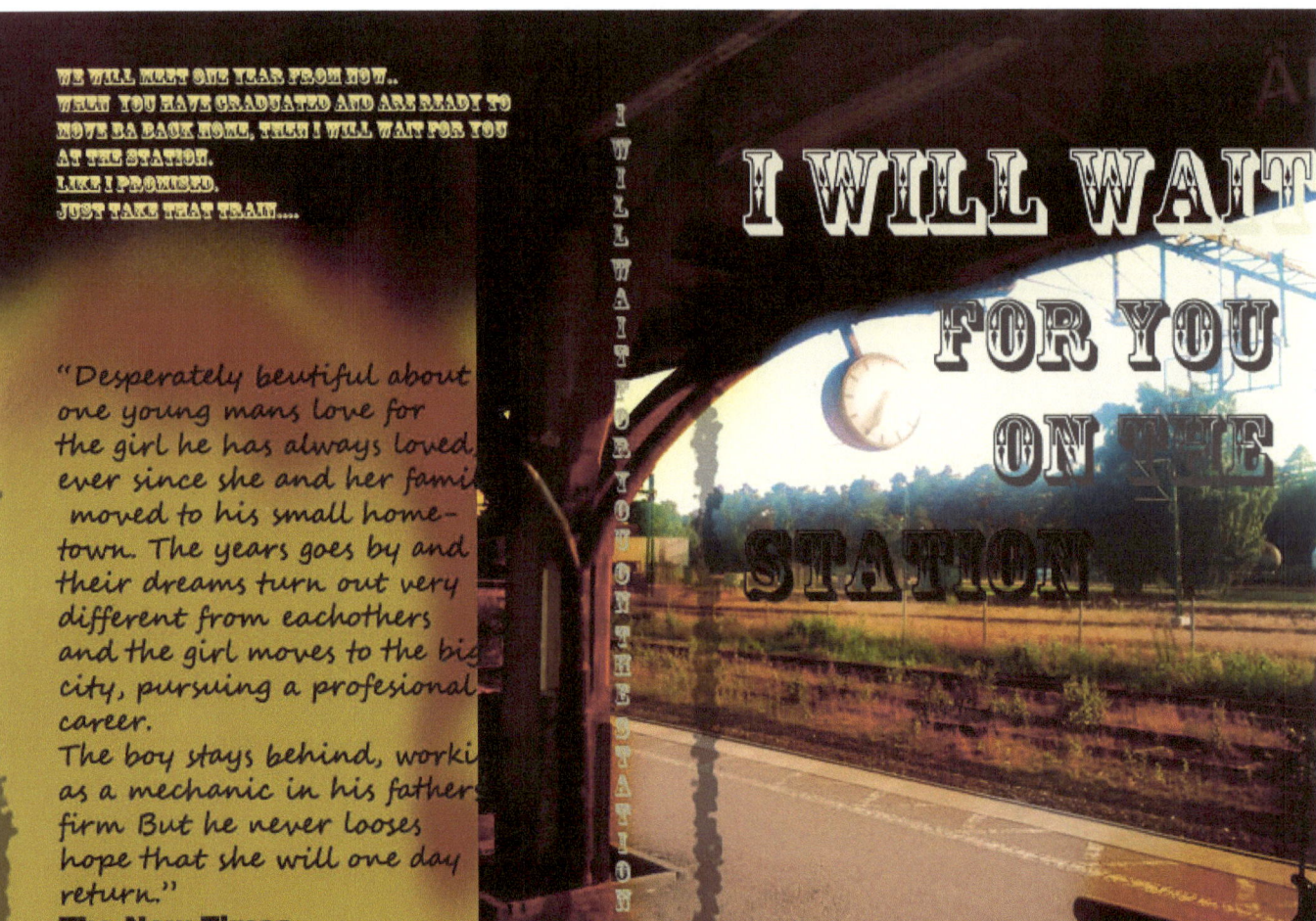

WE WILL MEET ONE YEAR FROM NOW..
WHEN YOU HAVE GRADUATED AND ARE READY TO
MOVE BA BACK HOME, THEN I WILL WAIT FOR YOU
AT THE STATION.
LIKE I PROMISED.
JUST TAKE THAT TRAIN....

"Desperately beutiful about one young mans love for the girl he has always loved, ever since she and her family moved to his small hometown. The years goes by and their dreams turn out very different from eachothers and the girl moves to the big city, pursuing a profesional career.
The boy stays behind, working as a mechanic in his fathers firm But he never looses hope that she will one day return."

The New Times

I WILL WAIT
FOR YOU
ON THE
STATION

Le Café is where all the artists, bohemians and writers have their daily café au¨lait, patisserié and sip up the atmosphere oozing from Paris busy streets.
Why don't you join them?

*"Lovely, simply lovely. Being a hard-working Londoner,, this little anthem makes me long for the bohemain dream of a life in Paris....
Vive la bohemé!"*

The New Times

Le Café

E&M Design

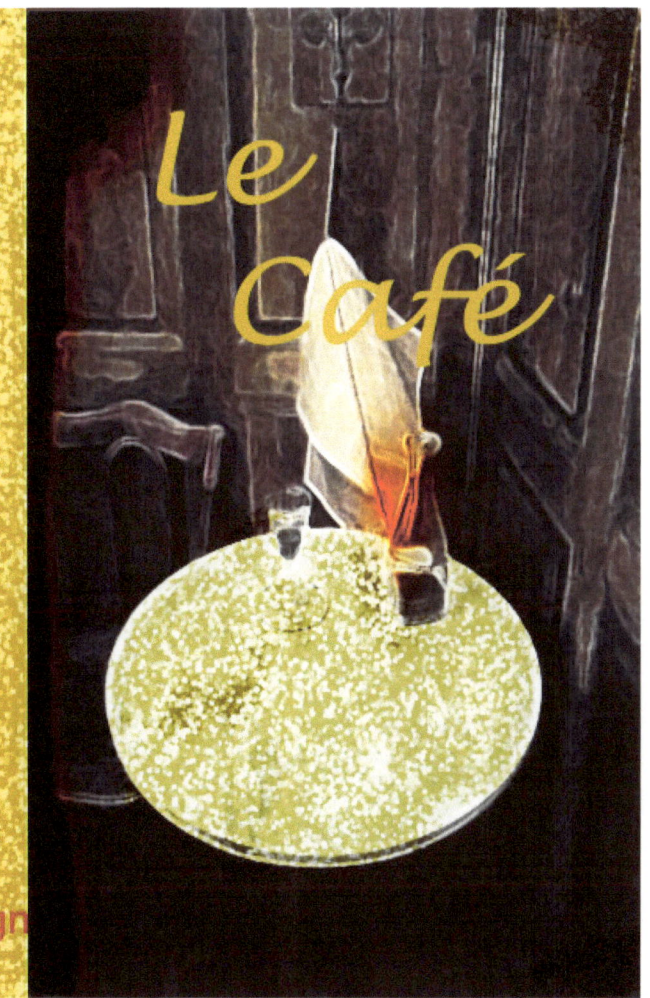

Le Café

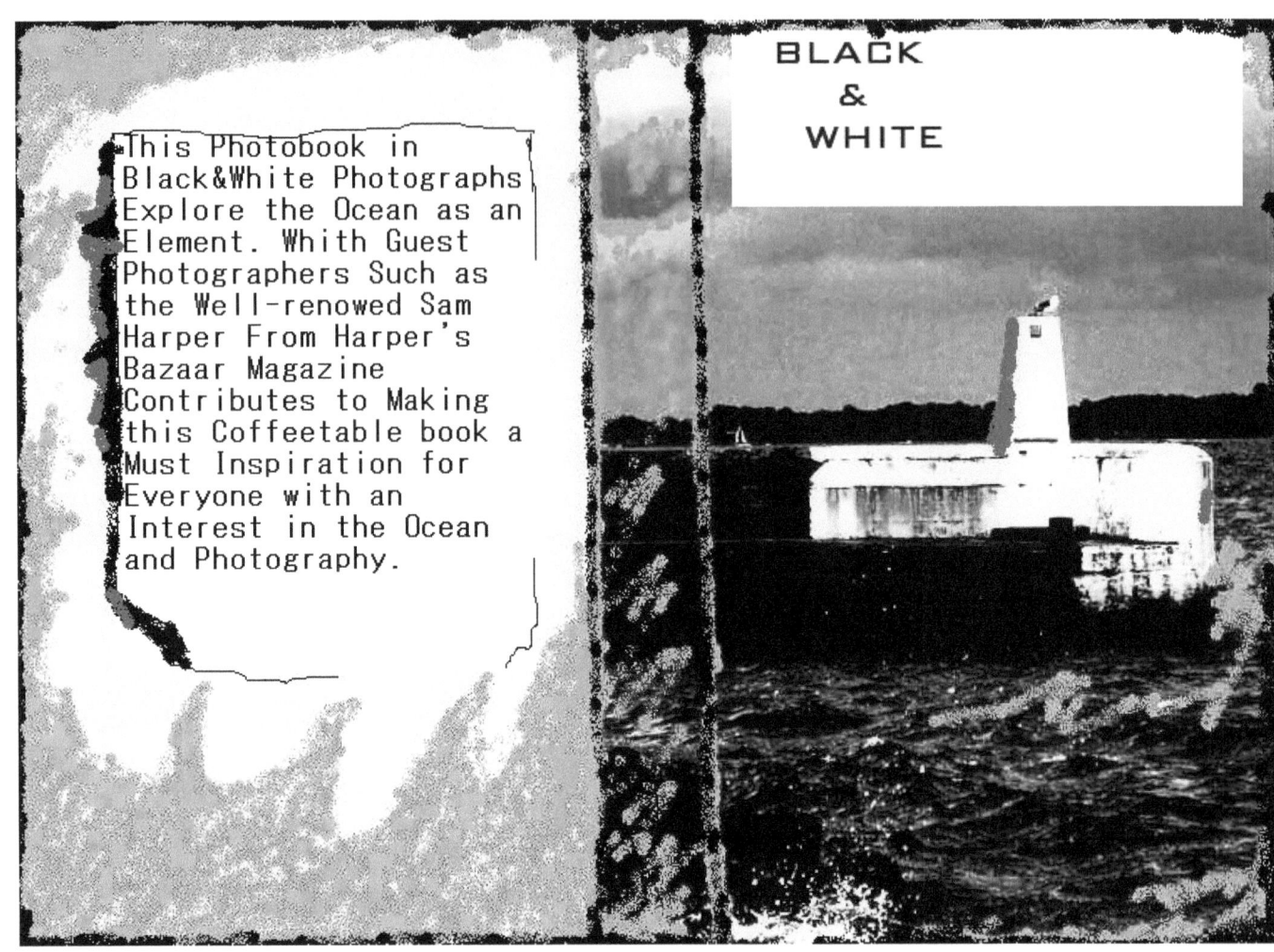

BLACK & WHITE

BLACK
&
WHITE

This Photobook in Black&White Photographs Explore the Ocean as an Element. Whith Guest Photographers Such as the Well-renowed Sam Harper From Harper's Bazaar Magazine Contributes to Making this Coffeetable book a Must Inspiration for Everyone with an Interest in the Ocean and Photography.

BLACK & WHITE

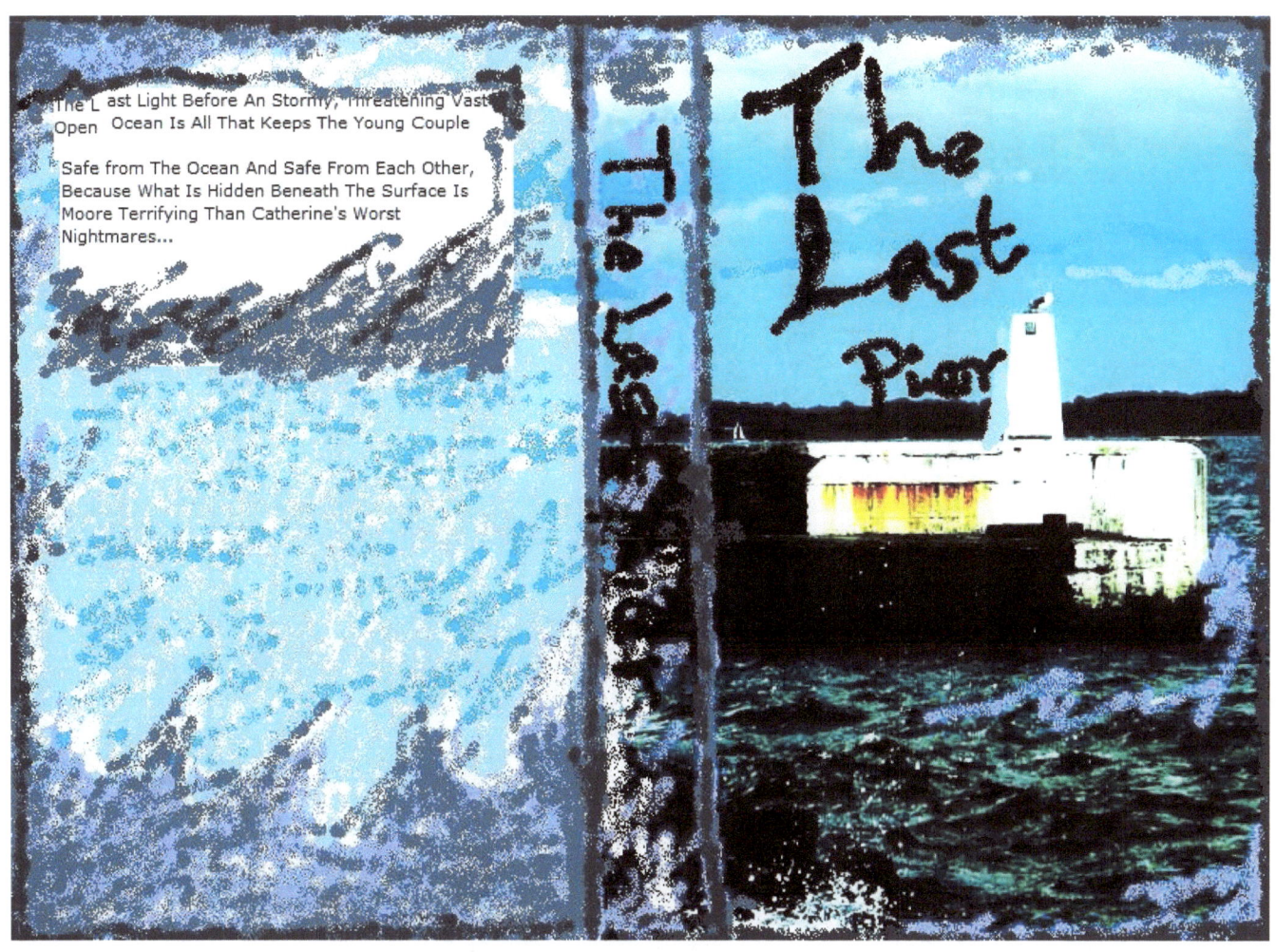

THE LAST PIER

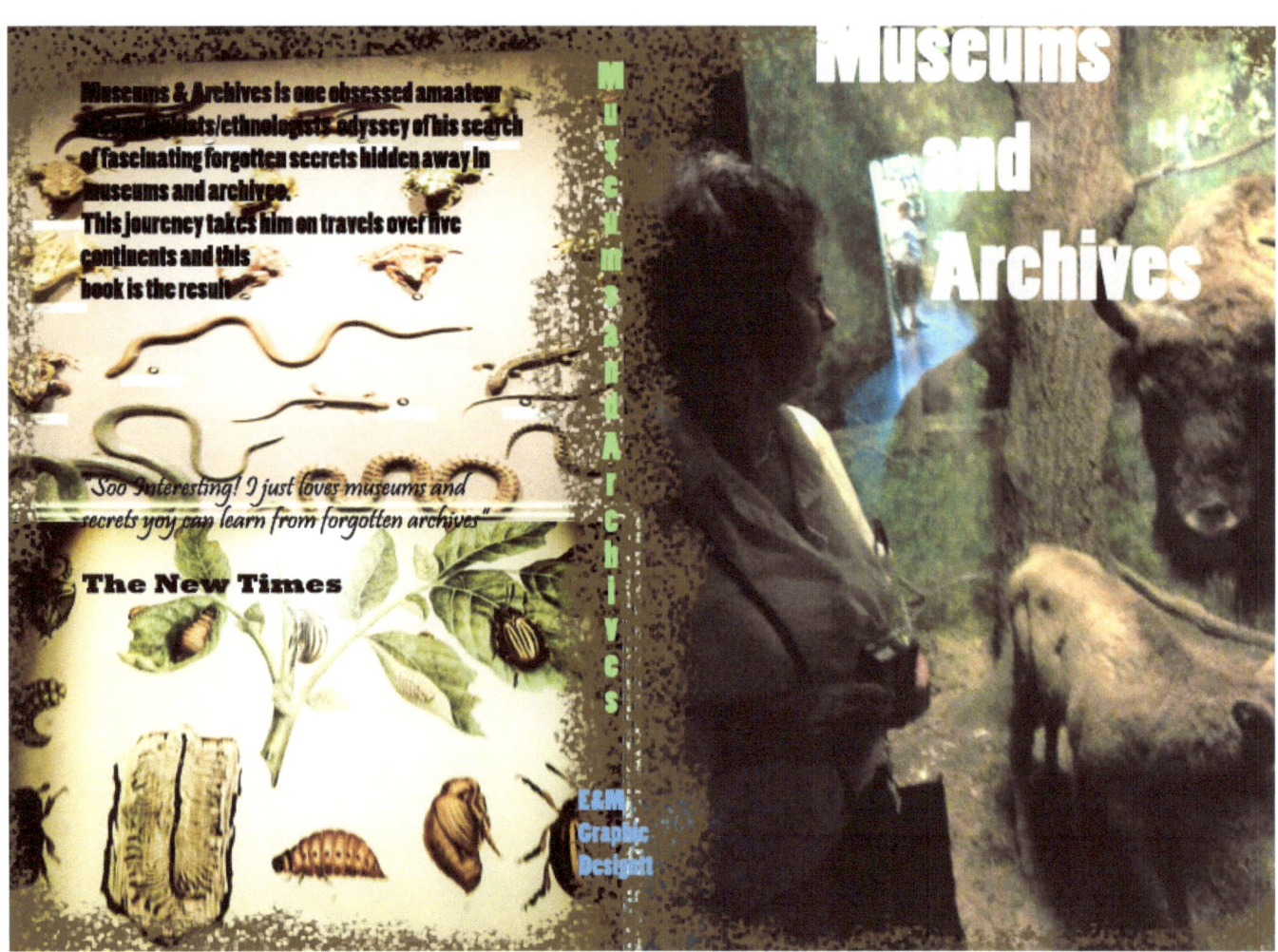

Museums and Archives

Museums & Archives is one obsessed amateur zoogeologists/ethnologists odyssey of his search of fascinating forgotten secrets hidden away in museums and archives.

This journey takes him on travels over five continents and this book is the result.

"Soo Interesting! I just loves museums and secrets you can learn from forgotten archives"

The New Times

Museum and Archives

E&M Graphic Design

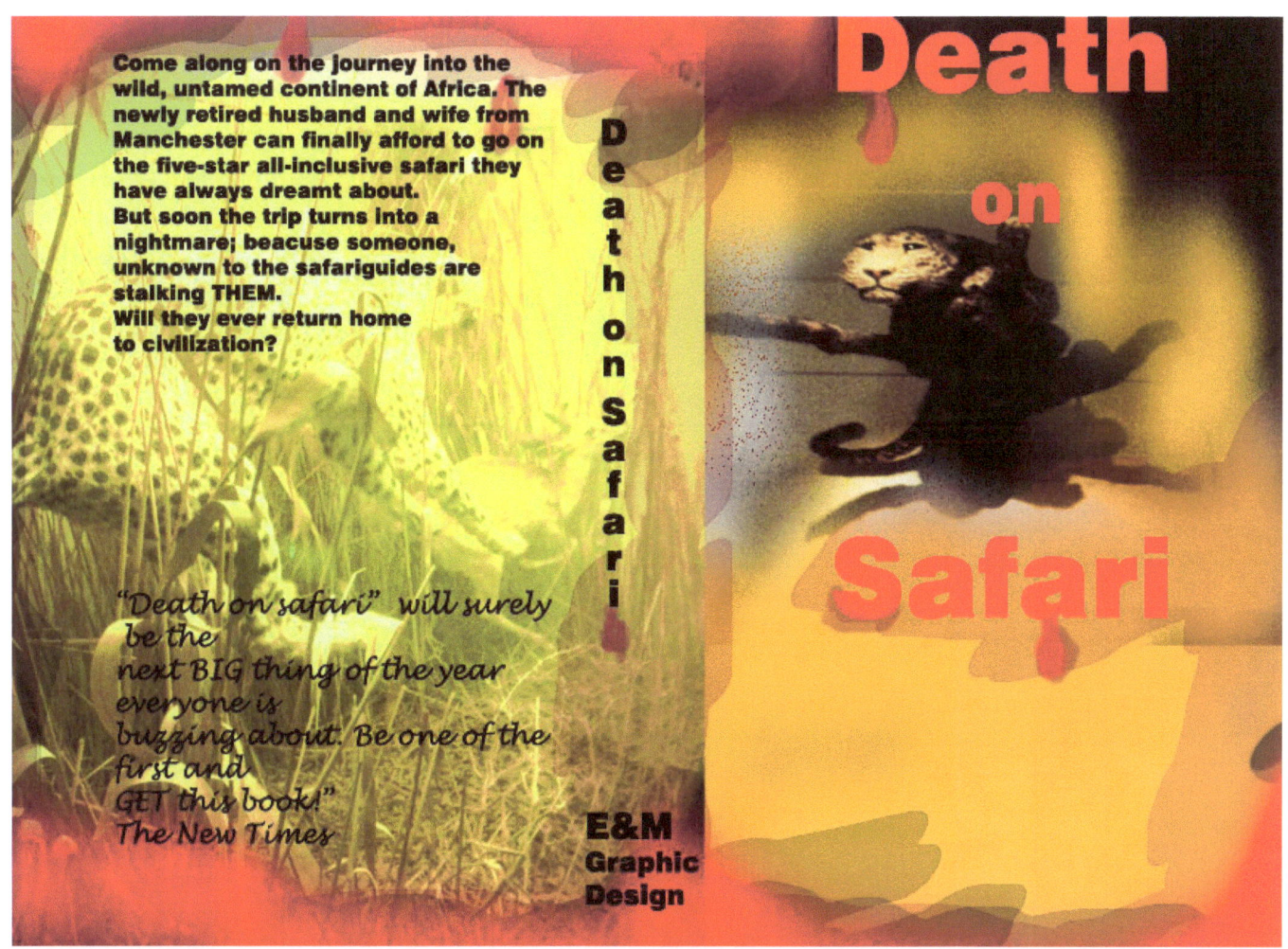

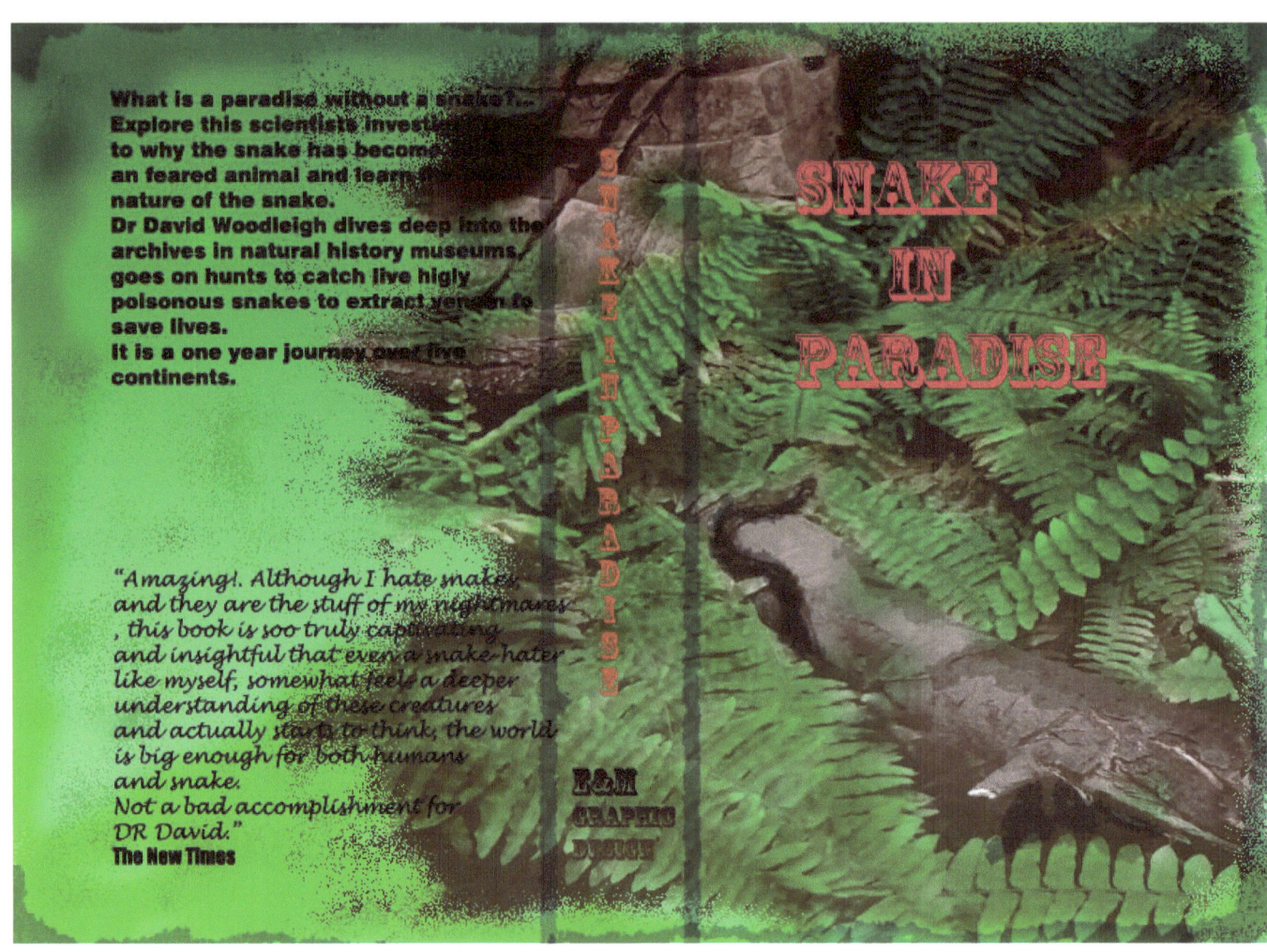

What is a paradise without a snake?...
Explore this scientists investigation to why the snake has become an feared animal and learn the nature of the snake.
Dr David Woodleigh dives deep into the archives in natural history museums, goes on hunts to catch live higly poisonous snakes to extract venom to save lives.
it is a one year journey over five continents.

"Amazing!. Although I hate snakes and they are the stuff of my nightmares, this book is soo truly captivating and insightful that even a snake-hater like myself, somewhat feels a deeper understanding of these creatures and actually starts to think; the world is big enough for both humans and snake.
Not a bad accomplishment for DR David."
The New Times

SNAKE IN PARADISE

B&M GRAPHIC DESIGN

SNAKE IN PARADISE

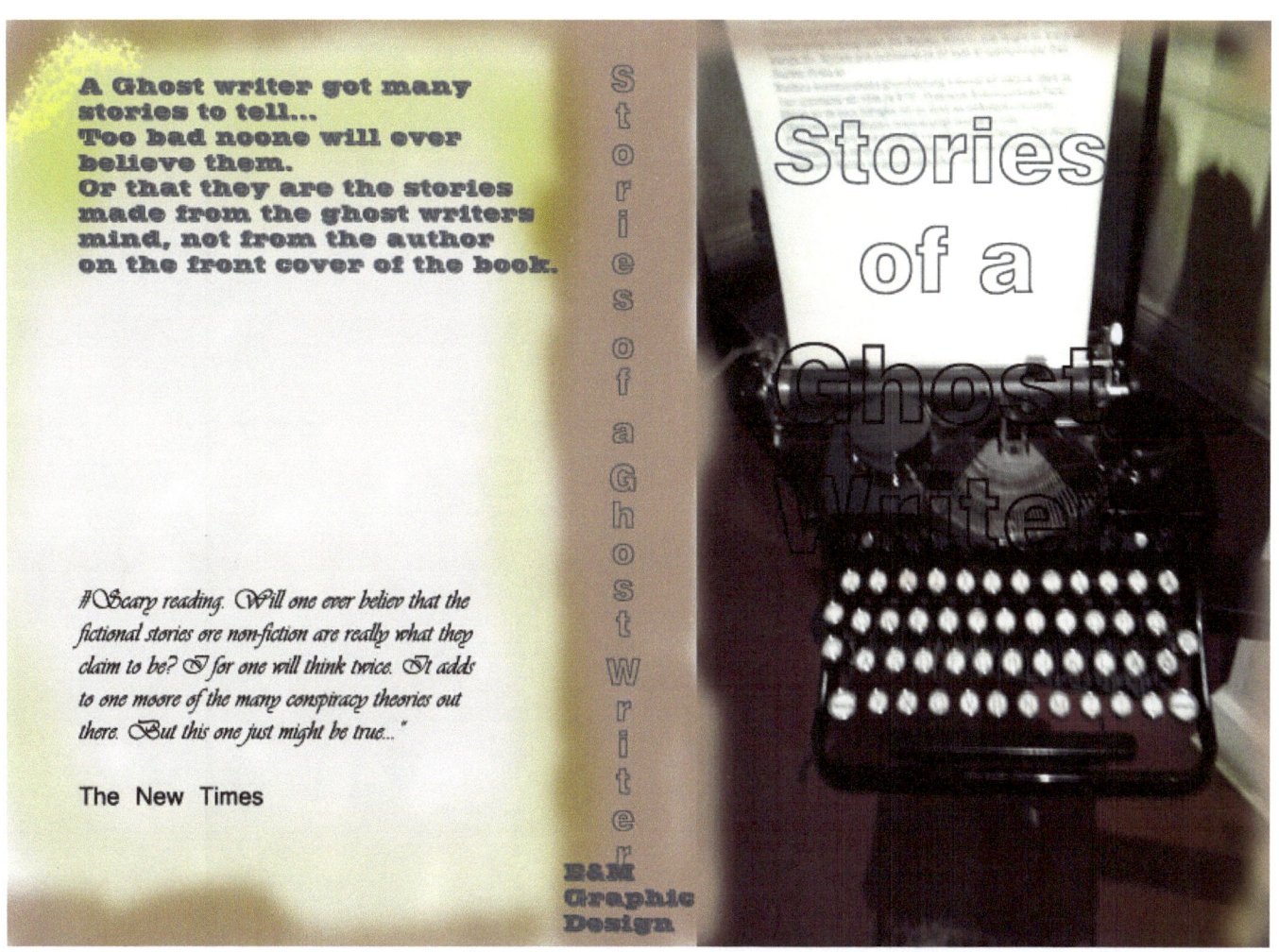

A Ghost writer got many stories to tell...
Too bad noone will ever believe them.
Or that they are the stories made from the ghost writers mind, not from the author on the front cover of the book.

"Scary reading. Will one ever believ that the fictional stories ore non-fiction are really what they claim to be? I for one will think twice. It adds to one moore of the many conspiracy theories out there. But this one just might be true..."

The New Times

B&M Graphic Design

STORIES OF A GHOST WRITER

THE BONE GARDEN

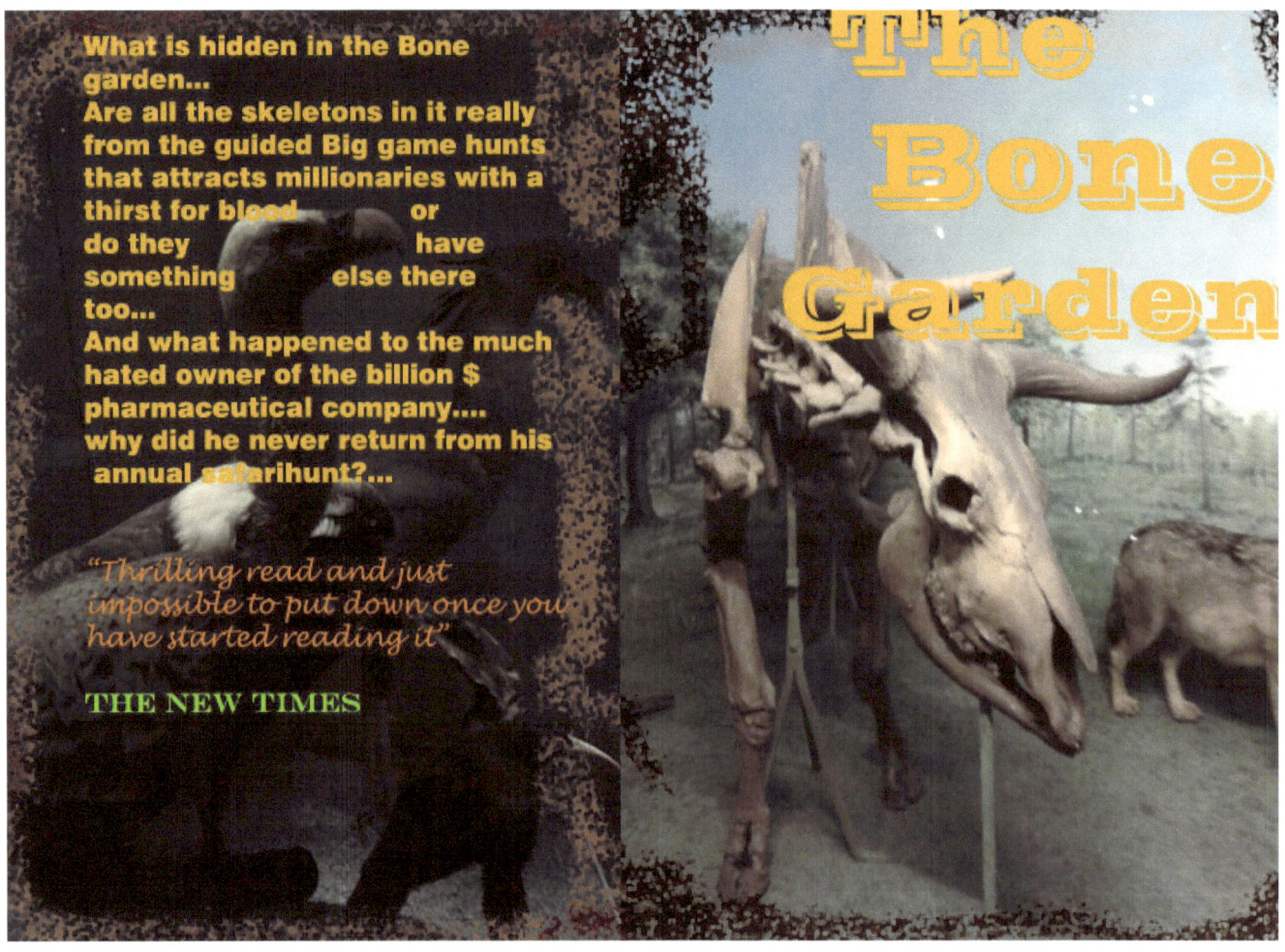

What is hidden in the Bone garden...
Are all the skeletons in it really from the guided Big game hunts that attracts millionaries with a thirst for blood........ or do they have something else there too...
And what happened to the much hated owner of the billion $ pharmaceutical company....
why did he never return from his annual safarihunt?...

"Thrilling read and just impossible to put down once you have started reading it"

THE NEW TIMES

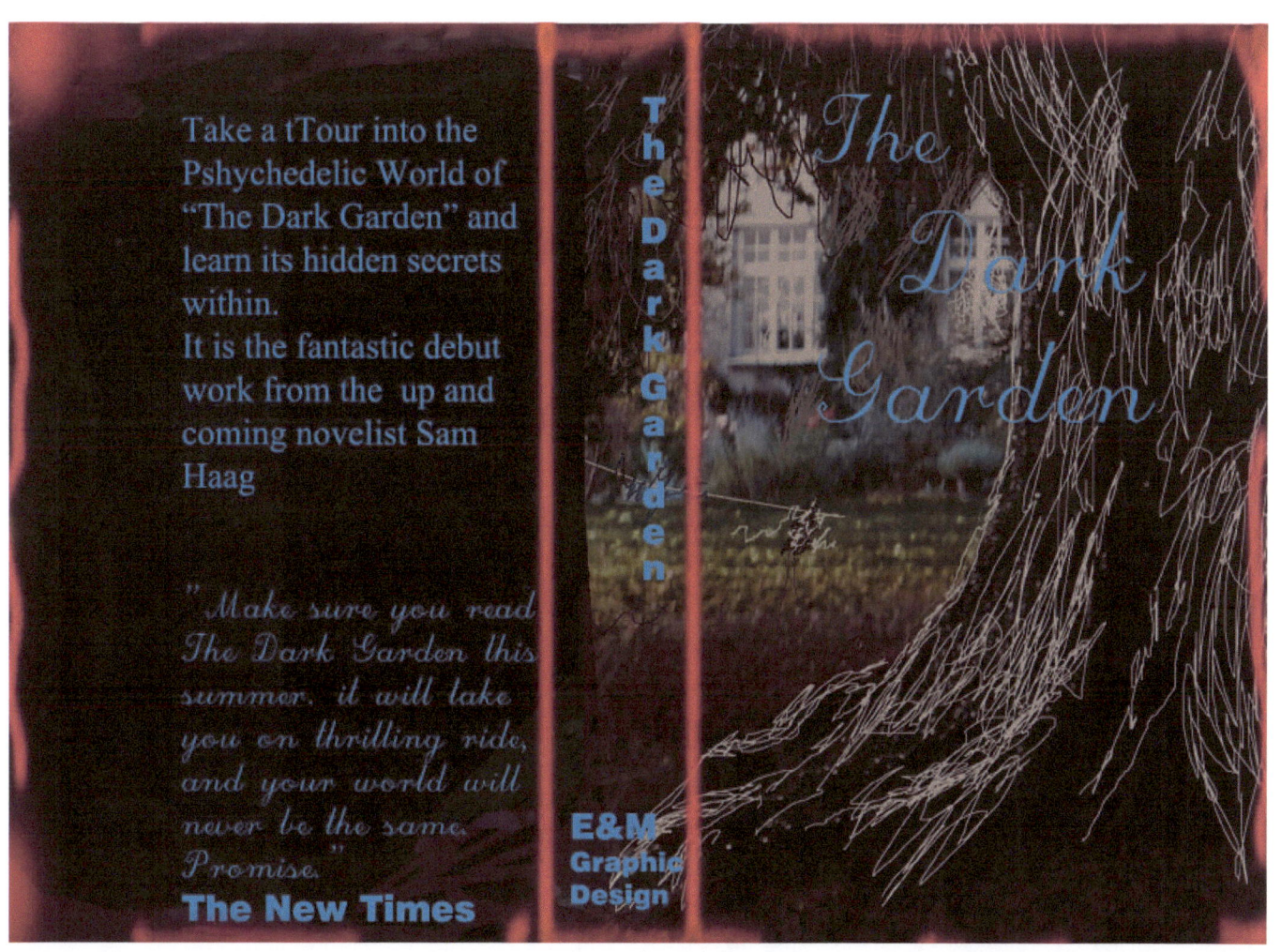

Take a tTour into the Pshychedelic World of "The Dark Garden" and learn its hidden secrets within.
It is the fantastic debut work from the up and coming novelist Sam Haag

"Make sure you read The Dark Garden this summer, it will take you on thrilling ride, and your world will never be the same. Promise."
The New Times

The Dark Garden

E&M Graphic Design

The Dark Garden

THE DARK GARDEN

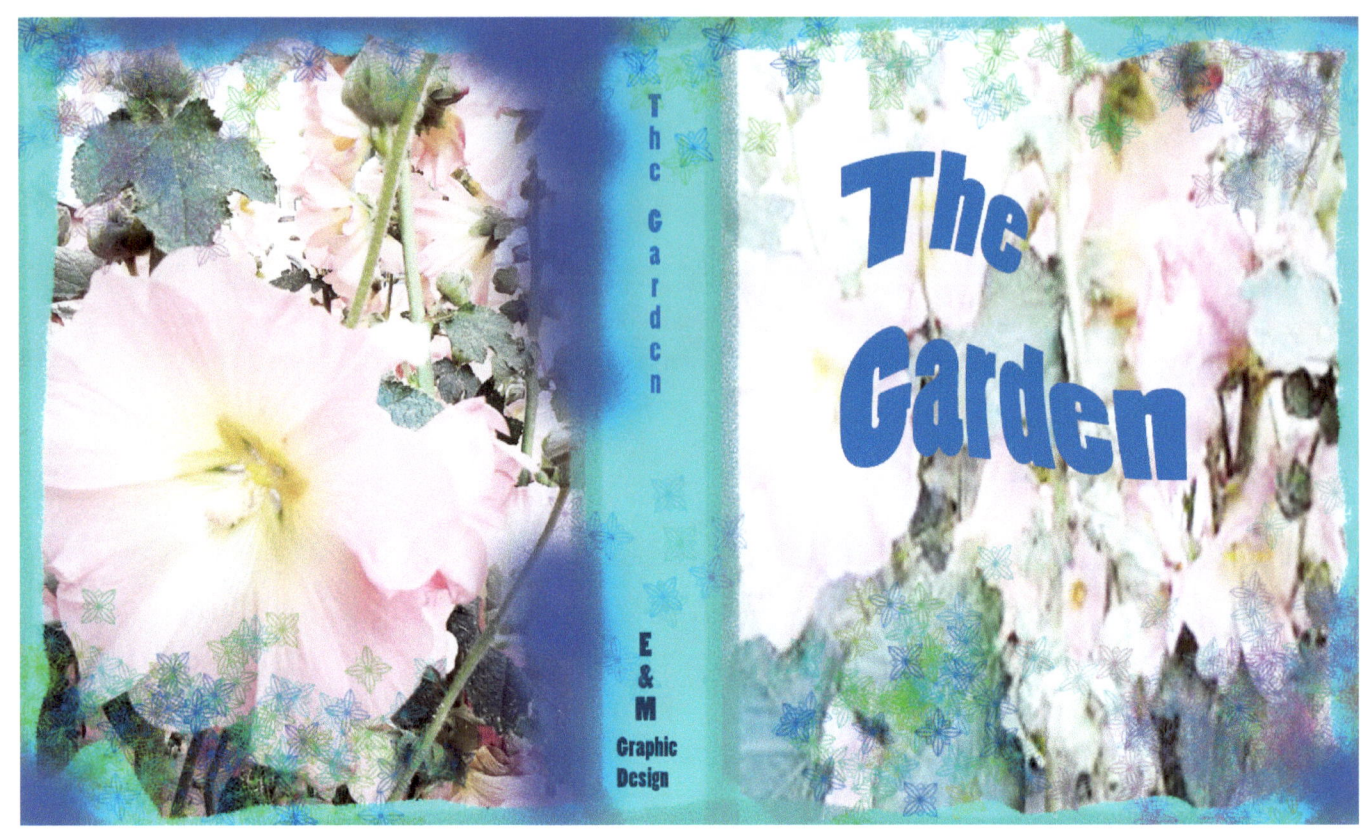

THE GARDEN

THE GARDEN

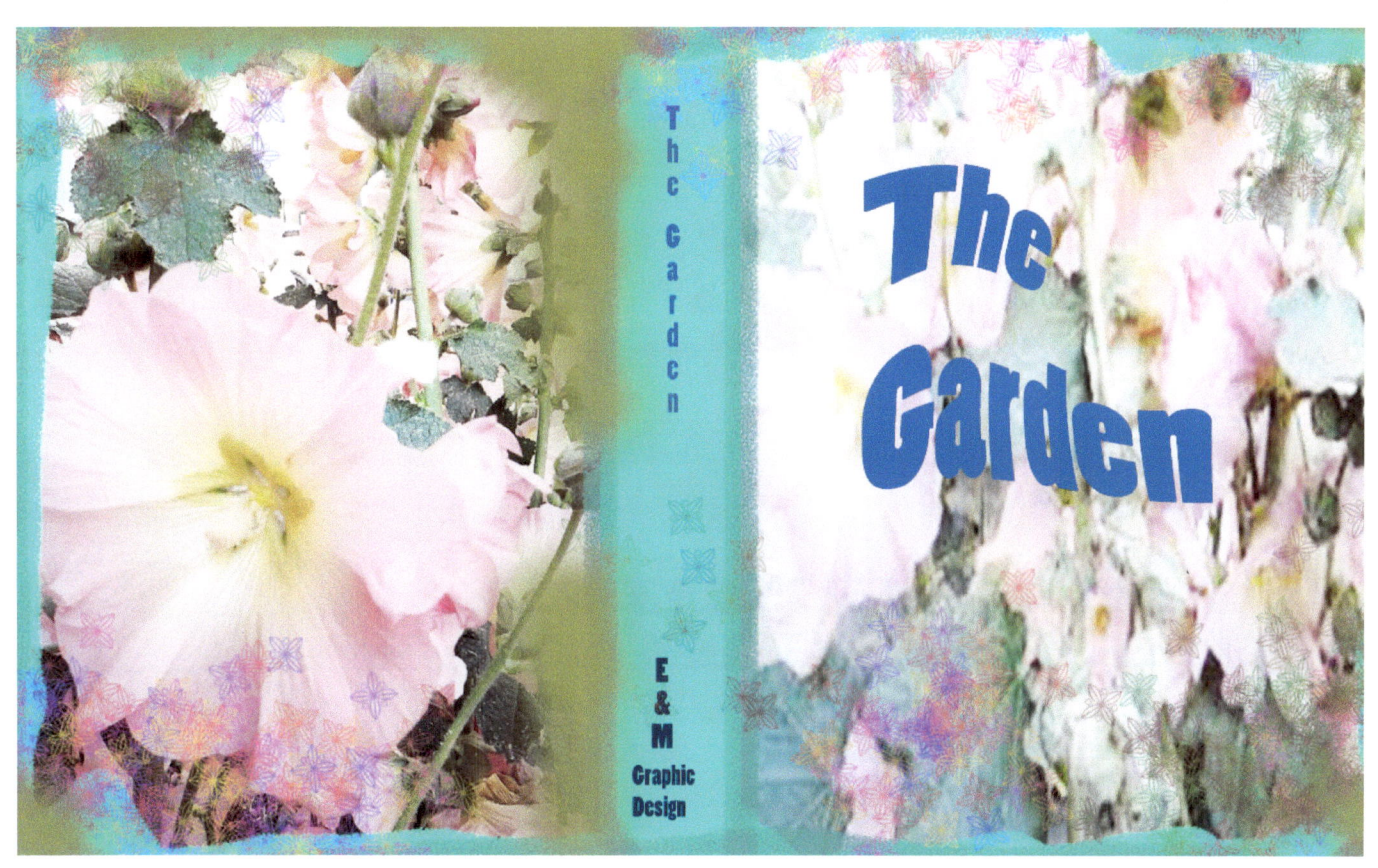

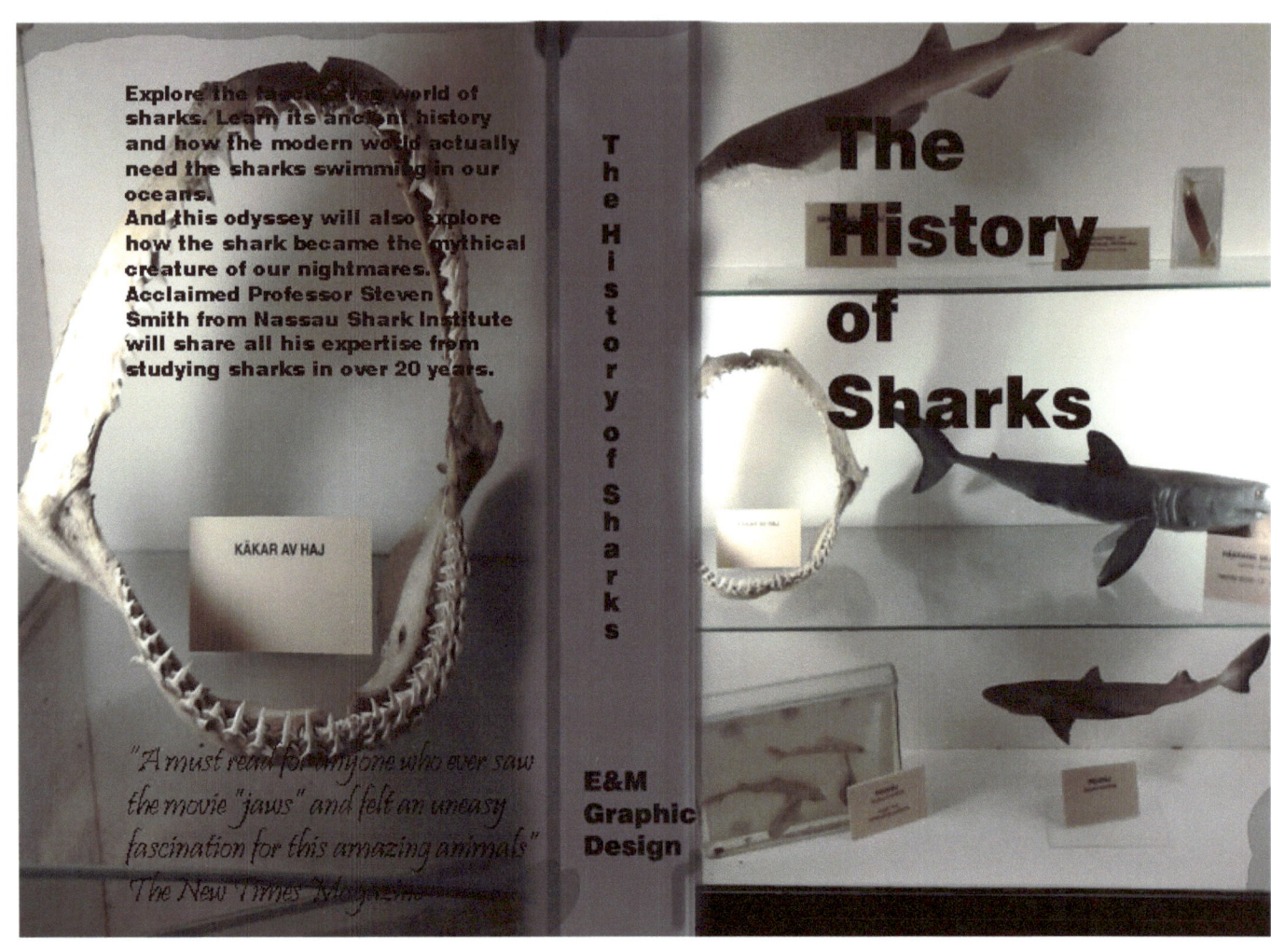

Explore the fascinating world of sharks. Learn its ancient history and how the modern world actually need the sharks swimming in our oceans.
And this odyssey will also explore how the shark became the mythical creature of our nightmares. Acclaimed Professor Steven Smith from Nassau Shark Institute will share all his expertise from studying sharks in over 20 years.

"A must read for anyone who ever saw the movie "jaws" and felt an uneasy fascination for this amazing animals"
The New Times Magazine

E&M Graphic Design

THE HISTORY OF SHARKS

THE JAZZ FESTIVAL

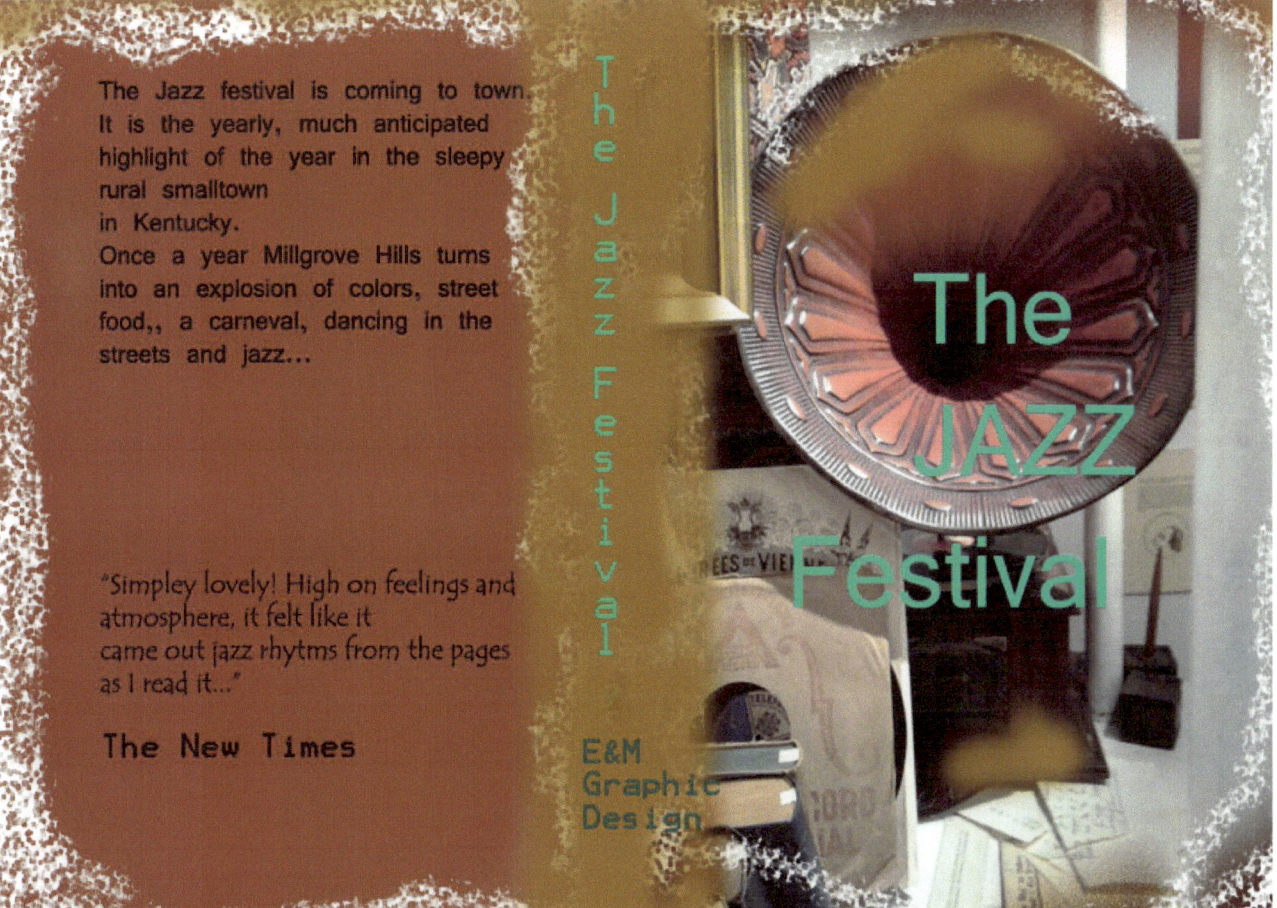

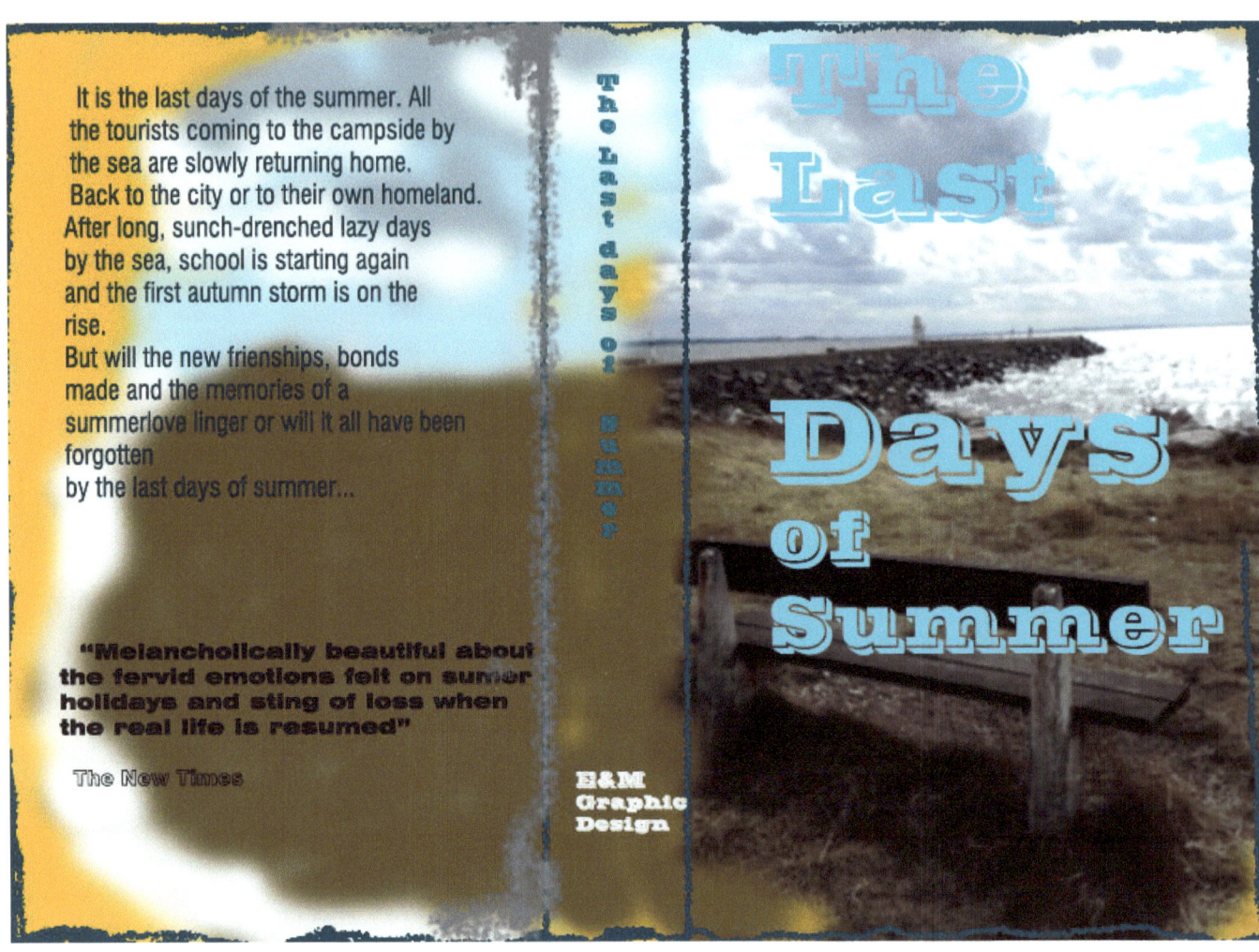

THE LAST DAYS OF SUMMER

Back cover text

It is the last days of the summer. All the tourists coming to the campside by the sea are slowly returning home. Back to the city or to their own homeland. After long, sunch-drenched lazy days by the sea, school is starting again and the first autumn storm is on the rise.
But will the new frienships, bonds made and the memories of a summerlove linger or will it all have been forgotten
by the last days of summer...

"Melancholically beautiful about the fervid emotions felt on summer holidays and sting of loss when the real life is resumed"

The New Times

Spine

The Last days of Summer

E&M Graphic Design

Front cover

The Last Days of Summer

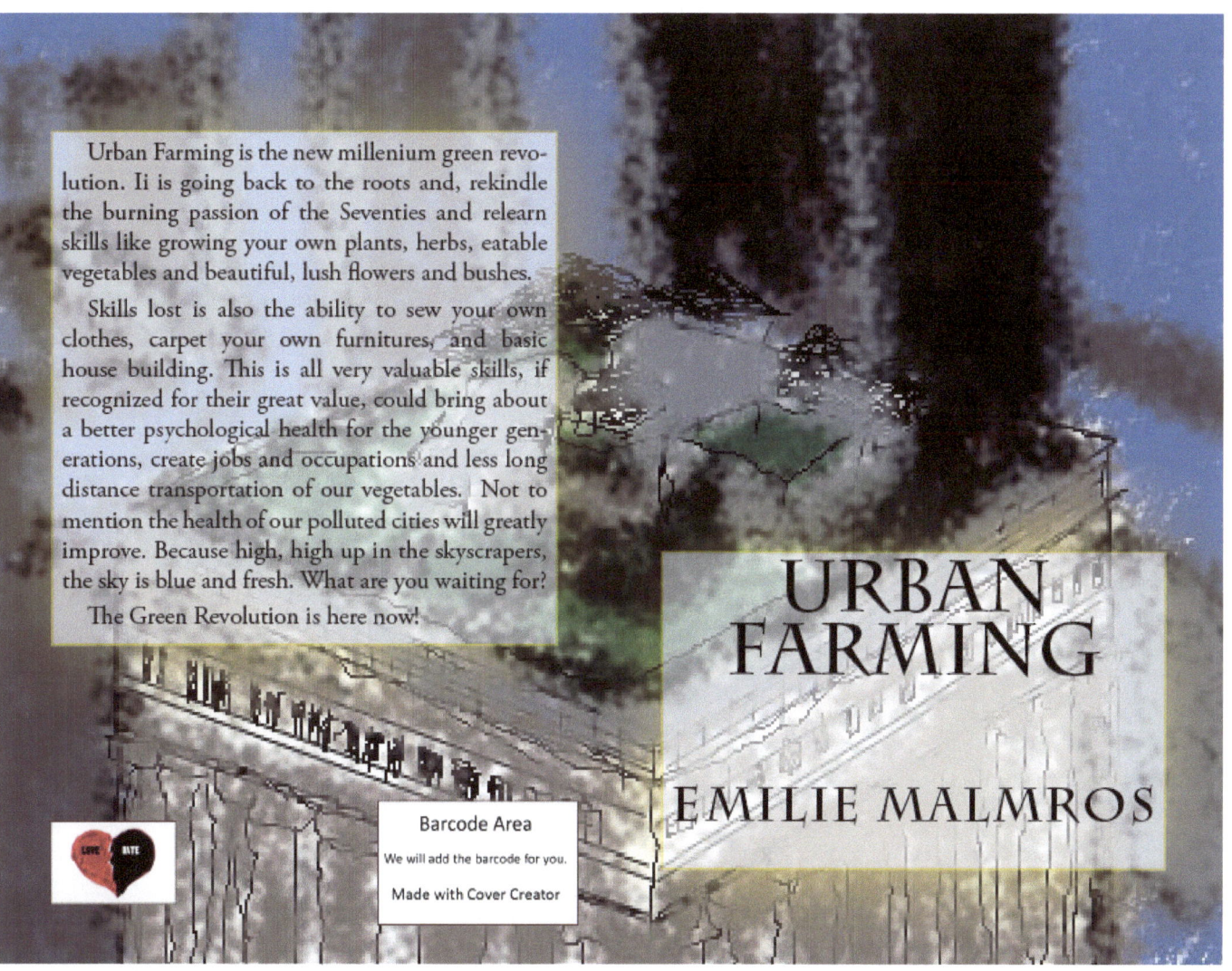

Urban Farming is the new millenium green revolution. Ii is going back to the roots and, rekindle the burning passion of the Seventies and relearn skills like growing your own plants, herbs, eatable vegetables and beautiful, lush flowers and bushes.

Skills lost is also the ability to sew your own clothes, carpet your own furnitures, and basic house building. This is all very valuable skills, if recognized for their great value, could bring about a better psychological health for the younger generations, create jobs and occupations and less long distance transportation of our vegetables. Not to mention the health of our polluted cities will greatly improve. Because high, high up in the skyscrapers, the sky is blue and fresh. What are you waiting for?

The Green Revolution is here now!

URBAN FARMING

EMILIE MALMROS

URBAN FARMING

Five years, 110 days, 5 hours and 10 minutes...

and then freedom... Janey has ben locked up in the Arkansas Womens jail for that time. Her crime? she killed the man who molested her ten years old daughter.
But everything has changed over that time, she is released with $20 and nothing moore. And to regain her now fifteen years old teenage daughter who has been in fostercare will prove one of her biggest challenges

"Shocking story with a "real-life" feeling to the story. Jane's faith haunts you and you will feel that the way you look at the world is altered"

The New Times

The Road to Freedom

E&M Graphic Designs

THE ROAD TO FREEDOM

THE FISHERMAN

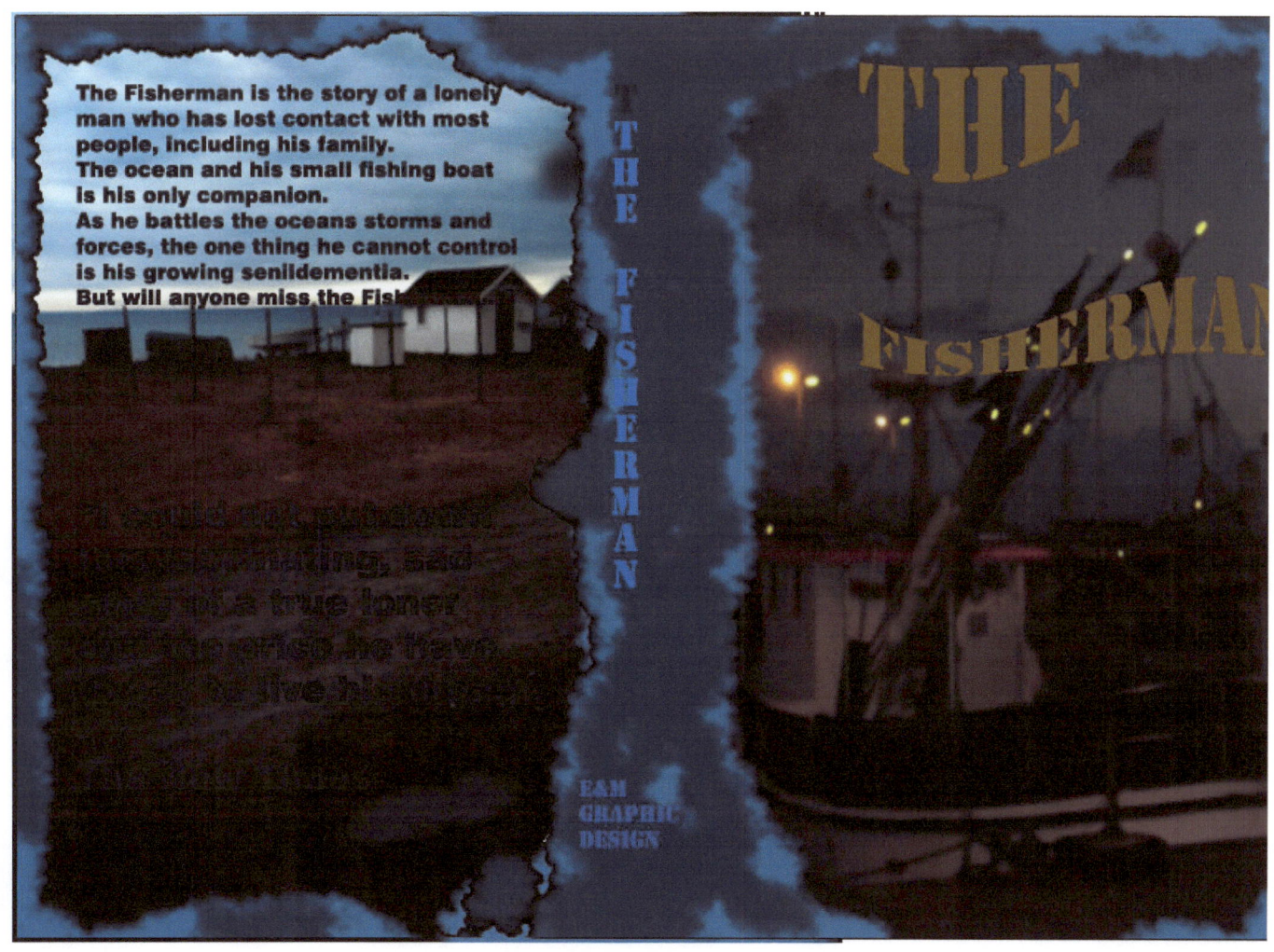

The Fisherman is the story of a lonely man who has lost contact with most people, including his family.
The ocean and his small fishing boat is his only companion.
As he battles the oceans storms and forces, the one thing he cannot control is his growing senildementia.
But will anyone miss the Fisherman

THE FISHERMAN

E&M GRAPHIC DESIGN

THE FISHERMAN